*Gustav Kraus, View of the city of Innsbruck
from the left bank of the Inn, with ... stle in the
... ca 1850*

Contents

**THE GOLDEN ROOF –
A BRIEF APPRECIATION** 2

A BRIEF HISTORICAL INTRODUCTION 4
The history of Innsbruck 4
The origins of the Neuer Hof (New Court) 5
The planning history of the Golden Roof 7
Emperor Maximilian I and Tyrol 7

NOTES ON THE ARCHITECTURAL HISTORY 11

TOUR 14
Approaches to the Neuer Hof in Innsbruck 14
The exterior 15
The balcony (bay window) – the Golden Roof 19
Tour of the interior 28
The courtyard and the rear building (the "Stöckl") 35

SUMMARY 36

BIBLIOGRAPHY 46

A brief appreciation

This building owes its fame to its 2657 gilded tiles. The Golden Roof is the best known building in Tyrol as well as one of the most important structures in the whole of Austria. It has been an essential feature of any publication on Tyrol since the start of Alpine tourism in the early 19th century. It is a landmark which characterizes the centre of Innsbruck's old town even more than the city hall or the Imperial Palace.

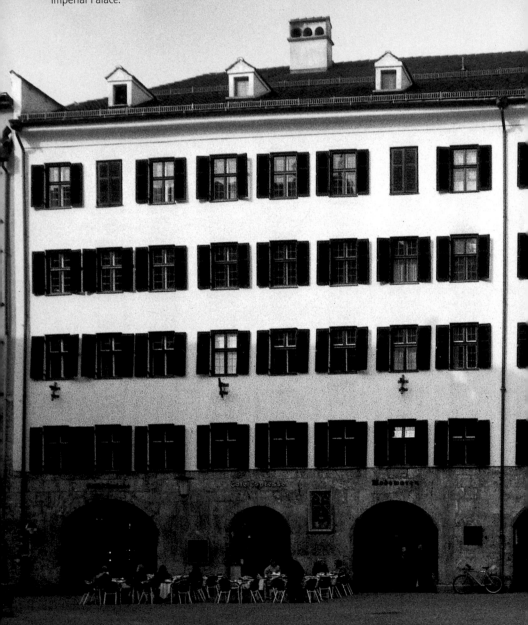

As a construction it is a "complete work of art", only a few examples of which remain from the transition period between the medieval and modern ages. The elaborate architecture combines ornamental and figurative sculptures and frescoes. The fame of the gold-covered bay window in the form of a balcony eclipses the whole building to which it belongs, which is known solely by the name of its most prominent component.

A brief historical introduction

The history of Innsbruck

INNSBRUCK LIES AT an altitude of 570m above sea level. The highest of the surrounding mountains are the Bettelwurf (2715m), Serles (2715m), Glungezer (2680m) and the Kleine Solstein (2655m). The name Innsbruck derives from the bridge over the Inn River. A bird's-eye view of a stylized bridge has been a feature of the city's coat of arms from the outset, albeit with minor modifications. The Latin *Oenipons*, on the other hand, is not derived from classical Latin: it came into being during the Renaissance.

The city of Innsbruck lies in a wide valley at the junction of the Wipp Valley running south-north with the Inn Valley running west-east. The Inn Valley was the land bridge between the Habsburgs' possessions in Austria, Switzerland and beyond, while the Wipp Valley linked southern Germany and Italy. As a result of this location, the city has developed into a traffic junction, the capital of Tyrol and the region's cultural centre.

The Wipp Valley links southern Germany and north Tyrol with the southern regions of east Tyrol and northern Italy in a direct line via the Brenner Pass, at 1372m the lowest pass in the main alpine ridge. This route has served as a prehistoric and Roman transport route, as the imperial road in the Middle Ages and the early modern era, as a pilgrimage route to the Holy Land, to Rome and to Santiago de Compostela, and as the most important trade route to Italy. In all such instances Innsbruck was the starting point and end point for the crossing over the Alps. The Inn River was used as an important transport route, above all for heavy loads, from the High Middle Ages to the 19th century. Horses on the bank were harnessed to the vessels travelling upstream and salt, corn, wood and wine in particular were transported by river. The building of the various railway lines brought an end to transport on the Inn.

There has been a railway line over the Brenner Pass since 1867 and the railway tracks were subsequently followed by motorways. Extending the Inn Valley to the West, the Arlberg Pass (1783m) links Tyrol with Vorarlberg, Switzerland and Liechtenstein and has been passable by road since 1785. A 10.3-km railway tunnel was built in 1883/84. Innsbruck has been a traffic junction of tremendous importance for the whole of Central Europe since the beginning. The traces of the intensive interaction are visible everywhere in the cultural, economic and academic life of the city. Even though the goods traffic has been a heavy burden at times, Innsbruck owes much of its rise and prominence to its strategic location.

The nucleus of the settlement was in Wilten, at the foot of the Bergisel, and in Hötting, at the foot of the Northern Ridge. Both have been the site of prehistoric finds and it is here that the oldest structures in Innsbruck are to be found. The valley itself, however, remained uninhabited until the mid-12th century. The origins of Ambras Castle, the castle of the Counts of Andechs, go back as far as the 10th century. The castle was destroyed by Duke Heinrich of Bavaria in 1133 and rebuilt at the end of the 13th century. Today Ambras Castle houses the only existing Habsburg portrait gallery as well as Europe's last Renaissance art and curiosity cabinet still surviving in its original location.

The first mention of the name "Insprucke" dates back to 1167 as the site of the bridge over the Inn. This settlement was located on the narrow strip of land between the left bank of the Inn and the mountain slopes of the Northern Ridge. The decisive step in the city's development into Innsbruck as we know it today came in 1180, when Count Berchtold V of Andechs acquired an area of land at the southern end of the Inn bridge, on the right bank, from Wilten monastery. The medieval marketplace was relocated in this area, now encompassing Innsbruck's old town. A castle and a circular fortification followed, whose structure is still clearly visible today. Innsbruck became a city in around 1200, which is recorded in a document of 1239.

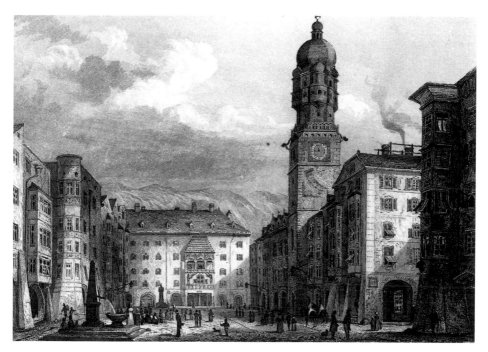

Herzog-Friedrich-Straße (the market square) with a view of the Golden Roof. Steel engraving based on a drawing by L. M. Bayrer, circa 1850.

The next phase of expansion followed in 1281 with the Neustadt (new town), the present-day Maria-Theresien-Straße, and prior to 1440 the Saggen district in the east of the city. It was only in the 20th century that the city underwent major expansion, incorporating the villages of Wilten and Pradl in 1904. This was followed by the present-day districts of Amras, Hötting, Mühlau, Arzl, Vill and Igls between 1938 and 1942.

The origins of the Neuer Hof (New Court)
The political direction of the entire region changed after the Habsburgs acquired Tyrol in 1363 through a bequest from Margarethe Maultasch. On the one hand, the Habsburgs tried to achieve a territorial link between their posses- sions in the east and in the west, and on the other hand, the mining activities, above all in the Inn Valley, became increasingly important eco- nomically. The political centre was therefore

moved to Innsbruck from Tyrol Castle and Mera- no, although it was only in 1849 that Innsbruck officially became the capital of Tyrol. In 1420 Duke Friedrich declared that he would now make Innsbruck his seat. Two town houses were acquired at the same time; these were to form the core of the Neuer Hof. It was not until the 17th century, however, that the entire complex between the present day Herzog-Friedrich-Straße, Pfarrgasse and Badgasse was completed. Significantly, the sovereign of the region took up residence in the heart of the town and not in Andechs Castle on the strategically important Inn bridge. This also explains the name Neuer Hof or Neuhof (new court) as opposed to the old court, which was the Andechs family seat. The conversion of the complex was completed within a few years and first mention of a chapel in the Neuer Hof was made as early as 1428. Duke Friedrich died on the first floor in 1439 "in the room under the chapel".

*The allied coat of arms of Archduke Sigmund and his wife
Katharina of Saxony, 1489. The round-arched frame contains
the three coats of arms of Austria – Saxony – Tyrol.*

His son Sigmund, nicknamed "rich in coins",
acquired a further building in the Pfarrgasse in
1459 but did not use it himself initially. Instead,
he had a tower-like annex, the rear "Stöckl", built
in the courtyard, comprising three large rooms
one on top of the other. The term Neuer Hof was
used in the deed of sale for the first time, and a
reference to Sigmund is incorporated in the stone
coat of arms which used to be located to the east
of the Golden Roof and a copy of which can be
seen on the west side today. Sigmund spent his
last years here following his removal from power.
The later Emperor Maximilian was the ruler of
Tyrol from 1490; he extended the former Andechs
Castle on the eastern edge of the city as his resi-
dence, Sigmund having built a new residence
there from about 1455 on. Today this is the site
of the much extended Imperial Palace. The Neuer
Hof, on the other hand, became primarily the seat
of the government authorities, Emperor Maximil-
ian having resided solely in the Imperial Palace.
The present-day appearance of the Golden Roof
building has little in common with that of the
Maximilian era. Its use as an administrative build-
ing, several severe earthquakes, particularly those
in 1572 and 1670, and finally its use as a military

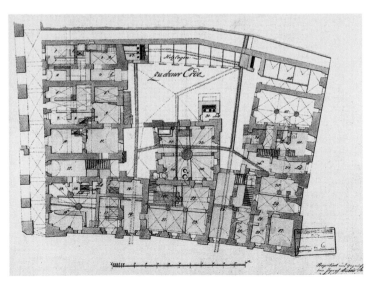

*Conversion plan, coloured
ground plan of 1822,
ground floor.*

barracks in 1780 have left their mark. It was only the purchase of the building by a consortium of Innsbruck citizens in 1822 which prevented its further dilapidation. They had the third floor lowered and a fourth storey built. The building has been the property of the city of Innsbruck since 1831.

The planning history of the Golden Roof

There are many legends about the building of the Golden Roof, and this is due not least to the very sparse historical evidence. Only one document has survived from the construction period, the transcript of a payment document from 1500 for the gilding of the shingles. A tenacious legend also has it that Friedrich "of the empty pockets" had already had an earlier balcony or bay window built, but there is no architectural evidence at all to support this.

Neither the actual reason for the construction of the projection, assuming there was one, nor its actual use seems to have been fully clarified. What is certain is that its location was selected very deliberately for reasons of display and prestige. The road from the Brenner Pass and Italy headed directly towards the Golden Roof after the city gate before turning to the west at right angles towards the only Inn bridge. The first thing that visitors to the city saw, therefore, was the Golden Roof.

Emperor Maximilian I and Tyrol

The power of the regional sovereigns played a much greater role in Tyrol than in other regions. The nobility did not enjoy the power of the manorial system as elsewhere. Instead, it was the mine owners who were important as the main sponsors of the rulers. Mining activity in Schwaz in the lower Inn Valley saw a tremendous upsurge as of about 1470 and silver and copper output increased dramatically in the decades that followed. The first silver talers in Europe were minted in Hall near Innsbruck from 1486 onwards. No other ruler in history was as devoted to the Tyrol region as Maximilian I. In addition to a

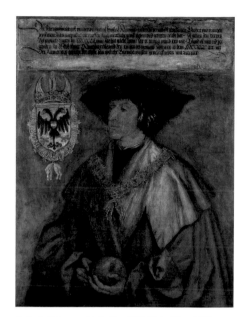

Portrait of Emperor Maximilian 1518/19 by Albrecht Dürer, now in the Germanisches Nationalmuseum in Nuremberg.

View of the Neuhof and the Golden Roof circa 1420, viewed from the city hall tower. Reconstruction drawing (M. Schmidt, HBR).

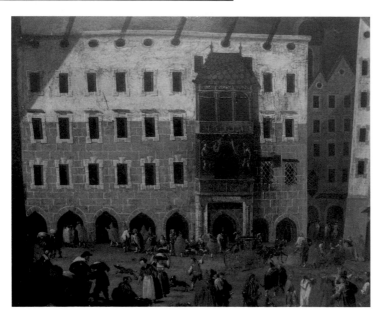

Josef M. Schmutzer, View of the Neuer Hof, painting from 1762. The Golden Roof building displays the high support walls of grey breccia.

secure basis for his military endeavours, it also provided him with ample opportunity for his favourite hobby, hunting. Of the various forms of hunting, stalking chamois was his favourite. The emperor's passion for hunting remains the subject of countless legends to this day, the most famous of which is the hunt in the Martinswand area near Innsbruck.

More than was the case for many other rulers, Emperor Maximilian was involved in wars the whole of his life. In addition to numerous more or less successful campaigns such as those in Burgundy, Hungary or Italy, the Alpine region, too, was the scene of war. The war against the Swiss was a particularly bloody chapter, with Tyrol suffering a devastating defeat in the battle on the Calva River on 22 May 1499 in which about 4000 Tyroleans lost their lives. In the Bavarian War of Succession of 1504, the later Emperor Maximilian was able to annex the law courts of Kufstein, Kitzbühel and Rattenberg for Tyrol. The year-long battles with Venice brought no decisive advantages despite the tremendous losses on both sides.

Closely related to these wars was the production of weapons and armour. The first armourer's workshop was founded in about 1460 by Archduke Sigmund in Mühlau near Innsbruck and was expanded systematically by Maximilian, who was also a declared jousting enthusiast. He allowed the armourer Konrad Seusenhofer to set up a workshop on the grounds of the present day Landhaus (provincial parliament building) and this became one of the empire's leading workshops, together with Nuremberg and Augsburg, within a few years. The emperor also had a number of innovations developed in the field of casting cannons in Innsbruck and surrounds. The standardization of the different weapon types and their ongoing improvement was a central feature of military planning. During times of peace, large quantities of arms and other military equipment were stored in the Innsbruck armoury on the outskirts of the old town. This is the only surviving armoury from the Maximilian era.

His second marriage was to Bianca Maria Sforza, the niece of the allied Duke of Milan. This was purely a marriage of convenience, a strategic

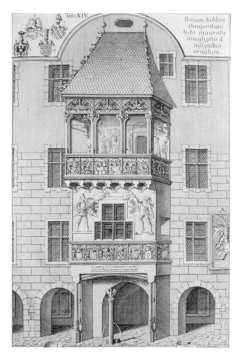

There are very few illustrations from the early era of the Neuer Hof. The first printed image was produced in 1750 by Salomon Kleiner.

move in the war against France for dominance in Italy, and was concluded in Innsbruck on 12 March 1494. While the emperor travelled around his empire almost non-stop, the royal household and his spouse spent most of their time at the Imperial Palace in Innsbruck. The palace consequently underwent major extensions, as was recorded by Albrecht Dürer in two watercolours. Of the legal provisions enacted by the emperor, the "Tyrol Landlibell" of 1511 is worthy of particular mention. In addition to numerous tax regulations, it established conscription for the defence of the province. To compensate for this, the Tyroleans were exempt from participation in any war outside the provincial borders. The emperor was also required to secure the approval of the Tyrol estates if he wanted to start a war affecting Tyrol. The Tyrol tradition of marksmen developed as a result of these rights, which were largely maintained until the 19th century. Another important law is the Tyrol High Court Regulations (Halsgerichtsordnung) of 1499, which had a major influence on numerous key (criminal) justice issues in the subsequent regional court regulations.

The emperor's last visit to Innsbruck took place after the Diet of Augsburg on 30 October 1518. The Innsbruck innkeepers refused to allow the baggage into the stables, however, on the grounds of significant unpaid debts. Already bearing the mark of approaching death, he left Innsbruck by boat and sedan again on 2 November. He died en route in Wels on 12 January 1519. In his will he determined that his teeth were to be removed from his corpse, his hair shaved and his

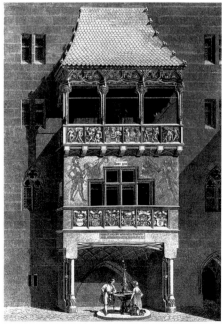

A reconstruction of the Golden Roof by Carl Heideloff (Ornamentik des Mittelalters, circa 1855, Plate XVII/5) with "false" Gothic windows beside the bay window and "correct" plain vaulting on the ground floor.

The most important dates in the history of Innsbruck

Circa 1500 BC First permanent settlement of the Inn Valley along the valley margins during the Bronze Age

15 BC Tyrol becomes part of the Roman province of Rhaetia

1133–1180 Establishment of a market town on the left bank of the Inn and construction of the first bridge over the Inn by the Bavarian Counts of Andechs

1167–1183 First mention of the name "Insprucke"

1180 Founding of Innsbruck's Old Town by the Margrave Berchtold V of Andechs Istria

1187–1204 Elevation to city and bestowal of city rights by the Margrave Berchtold V and Duke Berchtold VI of Andechs Merania, according to a decree issued in 1239 by Duke Otto II

1248 End of the Andechs dynasty. Albert III of Tyrol unifies the counties in the Adige, Eisack and Inn valleys under his rule

1267 First appearance of city seal and city coat of arms depicting a bird's eye view of the Inn bridge

1281 First city expansion and/or acquisition of the Neustadt (Maria-Theresien-Straße)

1358 Construction of the old city hall in Herzog-Friedrich-Straße

1363 The county of Tyrol including Innsbruck falls under the Dukes of Austria

1390 Last major city fire

1420 Duke Friedrich IV makes Innsbruck his residential seat

1442–1450 Construction of the city tower

1496–1500 Construction of the Golden Roof

1553–1563 Construction of the Hofkirche (Court Church)

1665 The Tyrol branch of the Habsburgs dies out thus ending Innsbruck's function as residential seat

1669 Founding of the university by Emperor Leopold I.

1806–1814 Tyrol becomes part of Bavaria

1809 Attempt to liberate Tyrol from Bavarian rule (the Battles of Bergisel)

1849 Innsbruck officially named as capital of the province of Tyrol

1867 Opening of the Brenner railway between Innsbruck and Bolzano

1938–1945 Austria is annexed by the National Socialist regime of the Third Reich; Innsbruck suffers major damage in the Second World War

1959–1971 Construction of the Brenner motorway

1964 Venue of the IX Winter Olympics. Innsbruck is made a bishop's see. Opening of the new airport

1976 Venue of the XII Winter Olympics

The Habsburgs in Innsbruck

1363–1365: Rudolf IV, Albrecht III, Leopold III
1365–1379: Albrecht III, Leopold III
1379–1386: Leopold III
1386–1395: Albrecht III
1395–1406: Leopold IV
1406–1439: Friedrich IV "of the Empty Pockets"
1439–1490: Sigmund "Rich in Coins"
1490–1519: Maximilian I

1519–1521: Karl V and Ferdinand I
1521–1564: Ferdinand I
1564–1595: Ferdinand II
1595–1602: Rudolf II
1602–1618: Maximilian III, Grand Master of the Teutonic Order
1619–1632: Leopold V
1632–1646: Claudia of Medici
1646–1662: Ferdinand Karl
1662–1665: Sigmund Franz

body buried in a simple coffin under the altar of the castle chapel in Vienna's Neustadt. The emperor's death mask can be viewed in the Golden Roof museum.

Emperor Maximilian I's most imposing legacy in Innsbruck is his cenotaph in the Innsbruck Hofkirche (Court Church). This is the largest imperial tomb in the Occident, the artistic quality of which is unmatched in central Europe. The most important artists of the age, such as Albrecht Dürer, Peter Vischer the Elder and Alexander Colin, were involved in its planning and construction. Today 28 of the planned 40 larger-than-life bronze figures are positioned around the cenotaph. The significant events in the life of the emperor are depicted in 24 very finely crafted white marble reliefs.

Notes on the architectural history

THE ORIGINS OF THE NEUHOF are thought to go back to the years following 1420. It was built as a four-storey building covering two properties, which extended from the Pfarrgasse corner to the window axis left of the Golden Roof. The foundations of both of the medieval predecessor buildings remain in existence, their façades being

behind the present day arcades. The Neuhof façade was probably entirely without bay window or balcony initially and there were possibly no arcades on the ground floor at first. The hall-like courtyard building, the "Stöckl", was built after the mid-15th century. Today the Golden Roof, that is, the balcony projection itself, is the oldest part of the entire complex façade and was attached to the older building in the closing years

M. Perathoner, The Neuer Hof and the Golden Roof, oil painting, circa 1780.

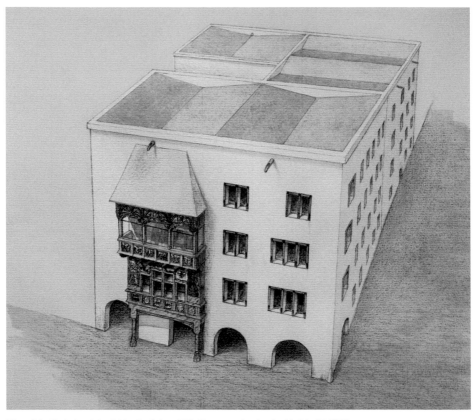

View of the Neuhof and the Golden Roof circa 1500. Reconstruction drawing M. Schmidt (HBR).

Dendrochronology

This is a method which has been used in building research and archaeology to determine the exact age of wood for several decades. The method is based on the growth of wood, which is dependent on climate and the seasons and which affects the thickness of the annual rings. The annual rings of the wood used in the building are measured using a core sample and the growth each year determined. Ideally the sample is taken from where the last annual ring has been retained under the rind (the waney edge). A comparison with wood samples from earlier dates thus allows the felling of the timber to be precisely dated to within half a year. Wood is always used fresh and so the last annual ring provides the date of felling and of construction. In the case of the Golden Roof the dating of the original roof structure produced a felling date of winter 1497/98. The roof would therefore have been installed on the completed building structure in the spring or summer of 1498.

of the 15th century. The building inscription "1500" indicates the date of completion. Earlier speculation that the building was completed in 1496 has remained inconclusive: the wood for its roof was only felled in the winter of 1497/98 and the construction period can therefore be assumed to have been between 1497 and 1500. The arcades on the ground floor were also in existence by this time if not before.

The Neuhof had three upper floors above the arcade level as well as a sunken ridge-and-furrow roof behind a high screen-wall. This meant that the roof was not visible from the road. The Innsbruck and Hall region was rocked by a strong earthquake in 1670. Numerous buildings in both towns subsequently had to be strengthened with supporting walls of coarse ashlar masonry. One such supporting wall is visible on the façade of the Neuer Hof. It extends past the 1st floor as high as the balustrade of the upper loggia level. The heights of the 1st and 2nd floors were reduced in the same process and the 3rd floor extended, resulting in a total of four usable floors. The building's attic floor was renovated at the same time and small horizontally oval openings, visible in an old view of the building, added to the screen wall of the old ridge-and-furrow roof .

A further substantial conversion of the façade and the building as a whole took place in 1822. The baroque windows created after 1670 were now given simple new frames. Windows were added, creating neo-classical axiality and severity. The former ridge-and-furrow roof was converted into a 4th floor which acquired a high hip roof. The entire façade was plastered uniformly,

Inscriptions on the façade

Coat of arms of Archduke Sigismund: "1489 – S – K", also:
"Sum dux ille pius, Scipio velut alter amicis
Aere salutiferam do pietatis opem.
Ergo eia superos lacrimis pie testor abortis
Ut mea Nestorios hauriat aura dies".

in English translation:
"I am generally known as a benevolent ruler, something of a second Scipio to friends
I use my resources of ore to provide benevolent help
Hence, with tears in my eyes, my pious call to the gods to stand witness,
May I draw breath for as many days as Nestor lived".

Above the ground-floor arch: "RESTAVRATOR POSTHORRENDOS CONTINVO ANO ET VLTRA PERPESSOS TERRAE MOTVS".
The highlighted letters correspond to Latin numerals (M=1000, D=500, C=100, L=50, V=5 and I=1) and thus equate to 1671. In translation: "Restored following the terrible and persistent earthquake now finally overcome".

Date above the middle window on the 1st floor: "XV co Jar":
(=15 cento/hundred years, 1500)

1st floor, wall surface adjacent to the balcony window: "RENOVATVM TERTIO ANO 17 82", namely: "Renovated for the third time 1782".

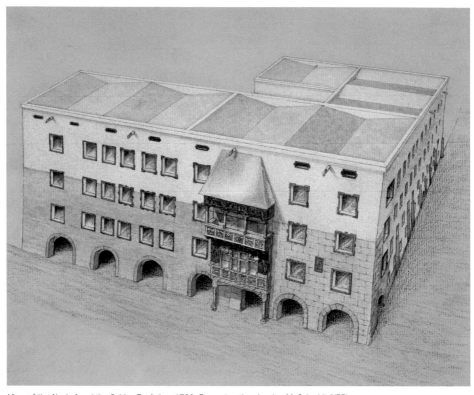

View of the Neuhof and the Golden Roof circa 1780. Reconstruction drawing M. Schmidt (HBR).

covering the breccia supporting walls of the upper section and thus giving the building its present day appearance.

Mention also needs to be made of the restoration work carried out in 1952, during which the Golden Roof's original stone reliefs were replaced with copies by Franz Roilo (Innsbruck). The originals are now protected from the elements as a loan from the city to the Tyrolean Provincial Museum (Ferdinandeum) in Innsbruck. The Golden Roof – Maximilianeum Museum in the Neuer Hof was opened in 1996.

Tour

Approaches to the Neuer Hof in Innsbruck

THE MEDIEVAL CITY of Innsbruck is extraordinarily small. The Hofgasse leads through the gate tower adjacent to the imperial residence (Hofburg) as one of the two axial roads in the Innsbruck old town running in a straight line towards the Inn River. About midway, it is crossed by the second axial road, Herzog-Friedrich-Straße, a wide street market extending to the south as far as the former city wall; its northern side is "blocked" by the Golden Roof. There is only a narrow alley, the Pfarrgasse, running past the Neuer Hof as far as St James's parish church, a cathedral since 1964. The two axial roads are linked by a few transverse alleys, while there is a

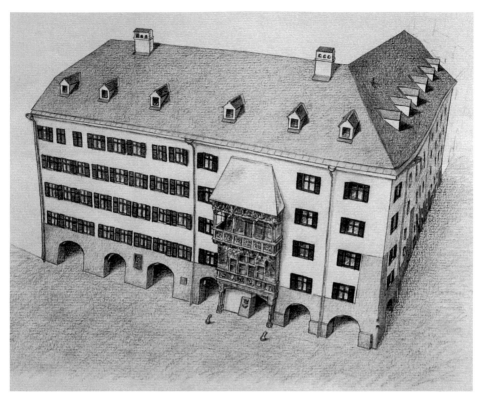

View of the Neuhof and the Golden Roof today. Coloured drawing by M. Schmidt (HBR).

walled alleyway on the inner side of the former city wall (the Stift- and Schlossergasse). On the outside, the city wall, which here looks like a broad row of houses, is encircled by a wide ring road following the route of the former moat (the Marktgraben and Burggraben). The extensive suburbs are located outside of this remarkably narrow ring wall. The Golden Roof, the old town's focal point situated just a few metres from the city gates, is visible from each of the city's former main gates

Innsbruck has just one large square within the medieval walls, namely the one facing the Golden Roof (Herzog-Friedrich-Straße). Anyone wanting to enjoy the view from above can do so from the neighbouring city hall tower, from which the whole of the city centre and of course Innsbruck's mountain panorama is visible.

The old town is a pedestrian zone and the Golden Roof can therefore be reached by foot only. The exterior and the courtyard are freely accessible. The museum, dedicated to Emperor Maximilian, who had the building constructed, is located on the 2nd floor and encompasses the most important rooms of the complex.

The exterior

The Golden Roof was built on to the Neuer Hof, first mention of which was made in 1420, as a combined bay window and balcony with a loggia. With nine window axes to the left and two axes to the right of this projection, the façade of the

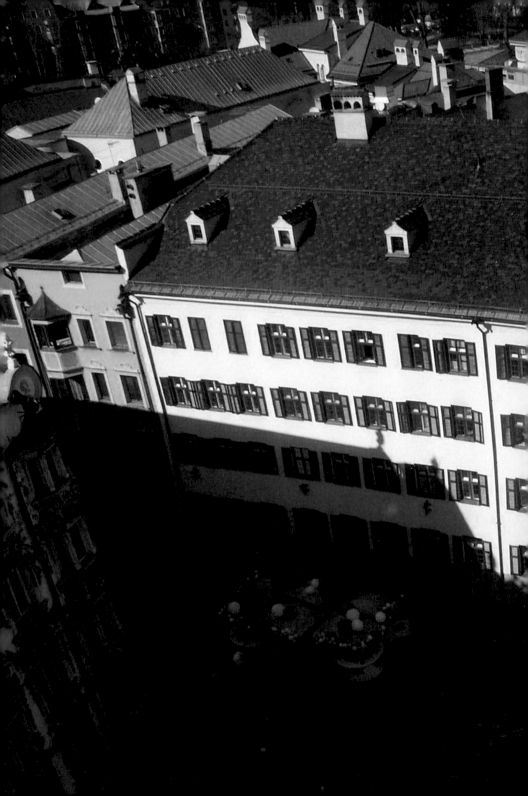

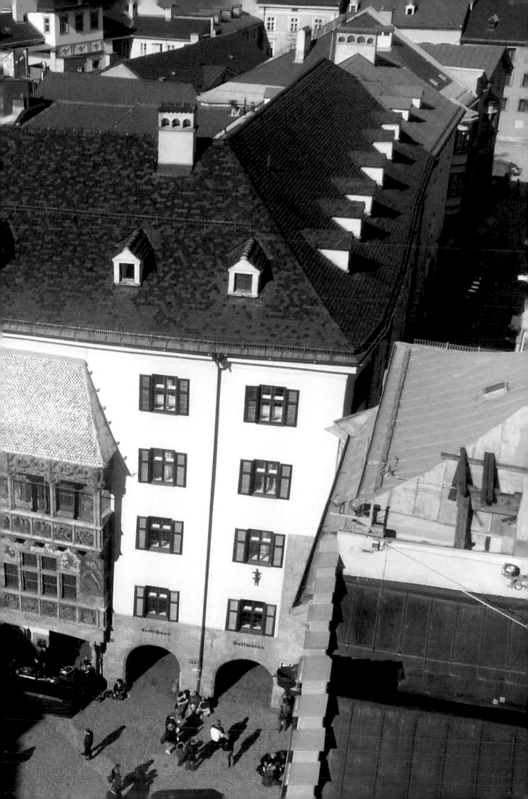

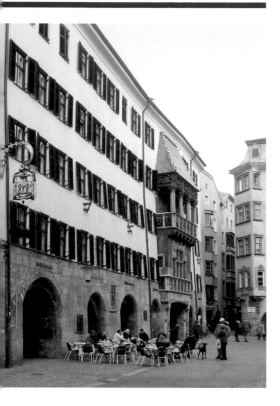

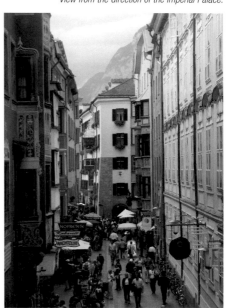

Neuhof is exceptionally wide, appearing somewhat monotonous today. This is related to the neo-classical conversion undertaken in 1822, during which all of the old window frames were removed from the street façade. The corner building on the Hofgasse provides an indication of what the baroque windows must have looked like, while the 15th- and 16th-century window shapes are visible in the Golden Roof courtyard building.

The façade does reveal a number of interesting details, however. The wall on the ground floor slopes forward slightly and is comprised of large grey squared stones. The stone used is breccia, also known as "Nagelfluh", a natural stone comprised of rubble and pebbles compressed into new stones under pressure. This stone was used in both Innsbruck and in neighbouring Hall to stabilize buildings damaged in the earthquake of 1670.

All the arcades comprise two arches behind one another at differing angles, the rear arch being the original and the front arch being part of the earthquake reinforcements. Almost all of the arches are segmental arches, namely neither round nor pointed – with one exception. Only the second arcade from the left is pointed and was the former entrance to the originally separate building to the left. There was initially no arcade directly underneath the Golden Roof, and possibly not even a narrow passageway. The present day flat arcade was added only in the 18th century at the cost of part of the balcony vault. The coat of arms to the left of the bay window dates from 1489. This is an exact copy, the original (now in the Tyrolean Provincial Museum) was located to the right of the bay window from 1671 on, its original position being unknown. The shallow stucco vaulting of the 16th century still exists

behind the three arcades to the right. The main entrance to the Neuer Hof is a segmental late baroque portal with a double-leaf door dating from 1822.

The bay window (balcony) – the Golden Roof

The Golden Roof is a three-storey projection consisting of a glazed section projecting from the façade and resting on supports extending to the ground below. The window level (1st floor) has a lavish, graduated series of windows in the middle as well as a small window on each side. The remaining wall surfaces are painted. The loggia level (2nd floor), however, has always been open. The rear wall of this floor is decorated with paintings. The whole construction no longer matches the floor heights of the Neuer Hof following the renovations. The sides of the structure reveal the extent to which the earthquake reinforcement of the remaining façade covered the projection and its balustrades.

The Golden Roof has marble supports on the **ground floor**. These are pillars situated in front of the façade, which have a complex Late Gothic

shape with round shafts on faceted pedestals and terminating in an ogee arch. The two pillars are linked by an extremely shallow arch, behind which is the balcony vault of the lower floor, the right half having been altered by the later creation of the passageway. It is thought that there was probably only a narrow entrance originally, or perhaps no opening at all beneath the bay window-balcony. The Late Gothic net vault below the bay window has a rhombic structure and small figures and ornamental vines on the front

The ground-floor arcade of the Neuhof with simple stucco vaulting dating from the 16th century.

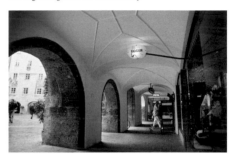

The earthquake of 1670 in Innsbruck and Hall

There have been reports of earthquakes in the Innsbruck region at relatively close intervals since the 13th century. None of them, however, was as strong as that of 1670. It began on 17 July 1670, with aftershocks recurring in August on an almost daily basis and then at least weekly through until July 1671. According to historical sources the town of Hall was the epicentre but Innsbruck was also badly affected.

It is no longer possible today to determine whether large numbers of buildings collapsed but the surviving buildings in both Hall and Innsbruck exhibit significant reinforcement measures and these are especially evident on the Golden Roof as well. High scarped (i.e. leaning) walls of breccia were used to support the buildings and the older portals and arcades from before the earthquake (i.e. the early 17th, the 16th or the 15th centuries) are often evident behind the new portals and arches on the ground floor. According to contemporary reports there were hardly any buildings without large cracks and countless chimneys appear to have collapsed; the plaster often came away from the masonry. Much of the vaulting is also thought to have suffered damage. The number of casualties in both towns appears to have reached up to a dozen.

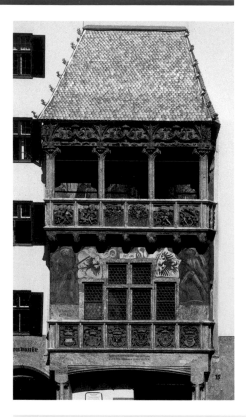

The main floors of the balcony-bay window.

Original support columns and earthquake reinforcements added later on the ground floor.

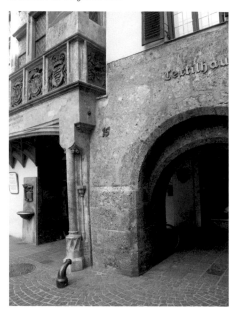

Heraldry

Coats of arms are the badges of the aristocracy, both in war (as a shield) and in peace and have been bestowed by the king since the High Middle Ages. A family is designated by a heraldic emblem, but this emblem can be expanded either temporarily or permanently by marriage arms (arms of alliance) or inheritance. In principle, therefore, a coat of arms is assigned to a family, and often to a specific individual, sometimes even for a precise period of time.

Coats of arms originally served as a sign of aristocratic background in general and for genealogical purposes in particular. The heraldic emblem was used for official events on cloaks and horse blankets, on weapons (hence the word arms), especially shields, as well as on buildings and building components, even on furniture and everyday articles. On official occasions the owner of the coat of arms (that is, the aristocrat) was announced by the herald, hence the word heraldry. From the Late Middle Ages on, untitled owners of coats of arms became increasing common, especially patricians and merchants, who were permitted to enter into contracts, for which they needed a heraldic seal.

Decorative figures on the ground-floor vaulting of the Golden Roof.

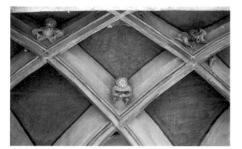

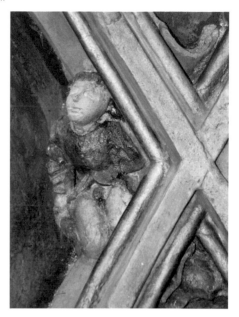

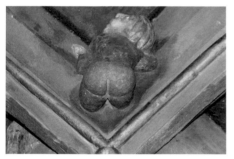

intersecting points of the ribs facing the square against the blue background of the vault. The little figures are wild, sometimes naked, creatures squatting in grotesque poses. One of them extends its naked behind to visitors, others their genitalia. A dwarfish man leaning on his arm looks down at the observer with amusement. This burlesque "welcoming committee" is not the only amusing feature of the magnificent – grotesque figures and scenes are to be found on almost all of the floors.

The **1st floor**, namely the window floor, has a four-part window. Older images show that the side windows originally only extended as far as the horizontal partition jamb of the middle window and were therefore somewhat lower. The paintings on the façade depict two larger-than-life standard bearers carrying the flags of Austria and the Holy Roman Empire. On the left side wall is the faded image of a female figure. The balustrade is lined by an armorial frieze, which is an outstanding artistic and historic document. The reliefs represent the sphere of influence and the claims to power of Maximilian I, who had the building constructed, which are specified in more detail by the inscriptions.

Six of the eight reliefs are mounted on the front, i.e. the visible side, and two on the narrow sides. The coats of arms are arranged in terms of hierarchy, the most important being in the centre: the coat of arms of the Holy Roman Empire, the two-headed eagle with the imperial crown ("KAISSER-TOM"), and the coat of arms of the Kingdom of Germany ("KINGRICH"), each with its crown. Both are Maximilian's personal coats of arms as

they both depict the Austrian-Burgundian shield as an inescutcheon; the shield is also surrounded by the chain of the Order of the Golden Fleece, worn by Maximilian following his marriage to the Mary of Burgundy (1457–1482), who died at a young age. The two centre shields are framed by the next most important Habsburg areas, the Kingdom of Hungary and the Duchy of Burgundy, represented by "K*ING LASLE", namely King Lazlo of Hungary (ruled 1440–1457), and "HERZOG FYLIPP", referring to Philip the Good, Mary's grandfather and founder of the Order of the Golden Fleece. On the outer left is the "compound shield" of the Duchy of Austria ("H*ZOG* OSTRICH"), on the outer right the serpent coat of arms of the Duchy of Milan ("HERZOG VON MAILA*T"), the coat of arms of Maximilian's second wife Bianca Maria Sforza (1472–1510). The side walls are occupied by the coat of arms of the Duchy of Styria ("STEIR") on the left and by the Tyrol coat of arms ("TIROL") on the right. Taken together, therefore, the reliefs depict the Habsburg possessions as well as Maximilian's personal alliances and dignities.

It is striking that the supporters at the sides of each coat of arms are differently designed. The narrow side to the left (Styria) features a man with an oriental turban and a naked, African-looking woman, to the right (Tyrol) is a naked wildman and another naked woman, both entangled in the ornamental vines. Such wildmen were widely used as supporters of coats of arms in the Late Middle Ages. Knights and soldiers serve as supporters at the front, while the king's coat of arms is supported by two griffins and the Burgundian coat of arms by two Burgundian lions. The only exception is the coat of arms of the Duchy of Milan, which is framed by the dual rods with buckets of water for fire fighting, a reference to a legendary fire in the city of Milan. The reliefs were originally coloured, the supporters and the background being white, so that the coats of arms, which were brightly coloured, and the golden lettering must have stood out impressively from the shining white background.

The series of coats of arms, in particular the central relief with the imperial coat of arms, gave rise to a long dispute about the dating of the Golden Roof. Based on this coat of arms it was supposed that the entire row on the front of the whole balcony was only created after 1508, after Maximilian was crowned emperor as his father's successor. This is technically possible as has been shown by the recent replacement of all of the reliefs. However, the inscription "Kaisertum" (emperor-ship) could also simply indicate the claim to the title not yet attained, meaning that the entire row could have originated prior to 1500.

The **2nd floor** of the projection is in the form of a loggia. The loggia framework with the main pillars, the balustrade, the shouldered arches at the sides and the eaves above are made of Kramsach marble. The balustrade features reliefs made of Mittenwald sandstone, with six on the front and two on each side. The projecting loggia balustrade is decorated with reliefs in the same order as those on the 1st floor, namely six reliefs on the front, but with two reliefs on each of the narrow

Standard bearer with the Tyrol flag on the bay window floor.

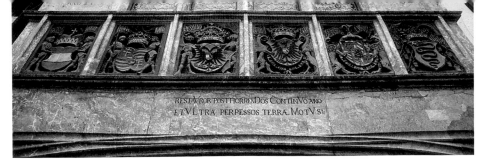

The armorial frieze on the 1st-floor balustrade.

sides here. Here too, the composition is also based on a pictorial programme centred on Maximilian. The series of reliefs as a whole depicts a Moorish dance. In this form of dance, which was very popular in court circles in the Late Middle Ages, the dancers used the most grotesque distortions, the dancer displaying the wildest movements receiving a prize. The adjudicator was always a lady who awarded the winner an item of value, usually a golden apple, as a sign of recognition.

It is precisely this event which is represented on the Golden Roof balustrade. In the centre, Maximilian can be seen twice, in the left hand relief in profile with his two spouses, Bianca Maria Sforza and Mary of Burgundy, and in the right hand relief frontally with a jester and an older man who is probably a high-ranking court official or councillor – his dress and the cap as headdress seem to indicate as much at least. The two middle reliefs show simulated balconies, with brocade drapes decorated with coats of arms, behind the balustrades of which Maximilian and the royal household are watching the Moorish dancing taking place to the side. Many paintings of the time show similar improvised tribunes. While in the right hand relief Maximilian presides over the events with an authoritative frontal pose, in the left hand relief he is turning to his spouse and seems to be indicating to her that she should

The imperial coat of arms with the two-headed eagle and the imperial crown.

The coat of arms of Bianca Maria Sforza.

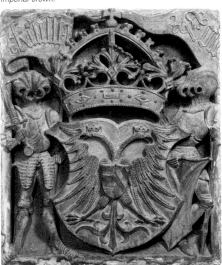

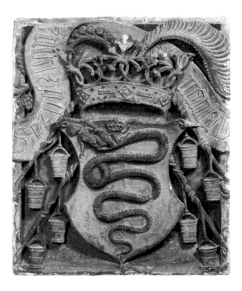

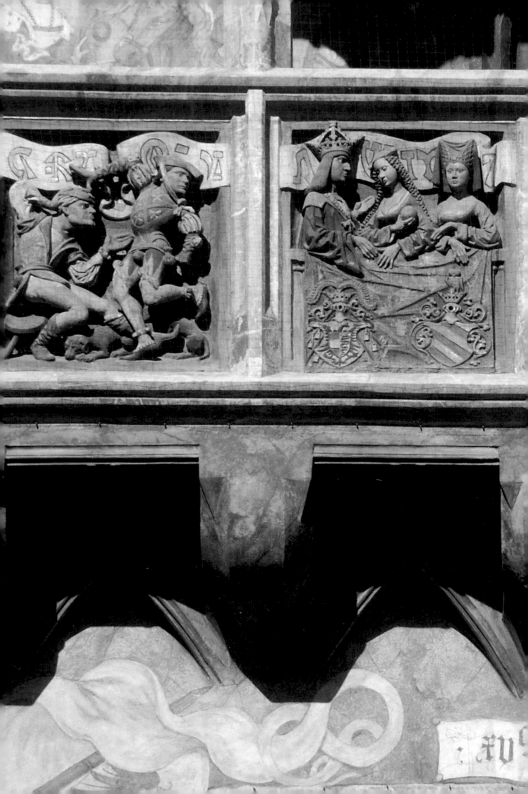

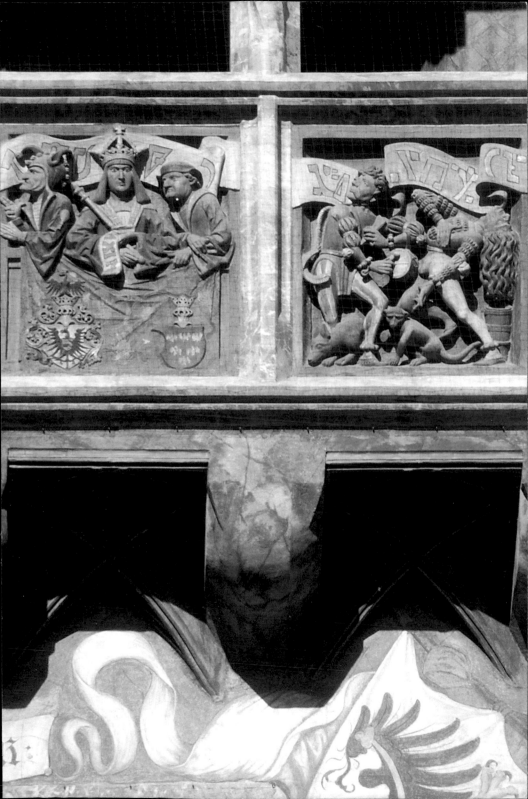

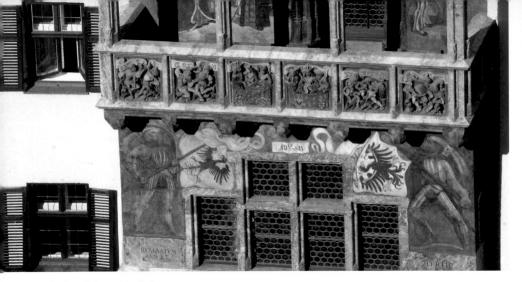

The bay window and loggia floors.

choose her favourite. His gestures are parodied by the jester who is pointing to the left. Maximilian's first wife, Mary of Burgundy, recognizable by the horned hat, which was old-fashioned by that time, looks straight ahead with a somewhat distant air.

The total of eight relief panels with the almost three-dimensional dance scenes are the really distinctive feature and a true artistic masterpiece. This is one of the most comprehensive series of scenes of Moorish dancing in existence in late medieval art. The panels depict a motley variety of grotesque positions and also of dress and headwear. Unlike the majority of other Moorish dance scenes, the sculptor has presented this series as a couple dance with the dancers reacting to one another with their dislocations. The weird effect is enhanced by the animals that jump about between the dancers' legs and thwart their movements. There is also a musician amongst the dancers who gives the beat with his drum; it is marked more strongly by the noise made by the bells on the dancers' hands and ankles. The participants' elaborate clothing also

indicates that the Moorish dance is a popular court dance. One of the dancers in the far right relief, explicitly identified as an aristocrat by the coat of arms on his back, is the court administrator Michael von Wolkenstein.

The oriental origins of the Moorish dance are emphasised by the banderole extending across the entire row of reliefs. There has been much speculation on the significance of the golden letters, which are similar to Hebrew characters but meaningless. The solution to the riddle lies in Burgundy and indicates that this is not language

Relief with Michael von Wolkenstein taking part in the Moorish dance (right).

Page 22/23:
The balustrade reliefs on the loggia. Depiction of King Maximilian and his wives with a court jester and a court official, framed by Moorish dancers.

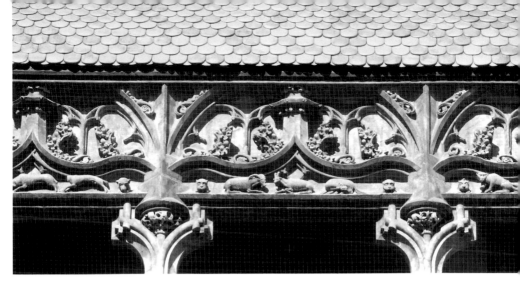

Ogee arch and animal frieze above the loggia.

using a secret code of Maximilian's, but rather a form of pictography. During the preparations for a celebration at the Burgundian court in 1428 the court painter Hue de Boulogne was commissioned to create silk robes in a variety of colours and in "bizarre shapes" for the Moorish dancers. These robes were to be elaborately decorated with gold and silver as well as with "lettres sarasinoises" (= Saracen writing). These letters were purely decorative and oriental in character. There is every indication that the lettering on the Golden Roof's banderole too is of no more than visual significance.

The area above the loggia opening is enhanced by further sculptural details. The capitals support timberwork with a variety of animals such as a monkey, deer, rabbit, bear and ibex, as well as lions, goats and dogs, either lying down or

Coloured roofs

Reddish brown tiles and natural stone (dark slate or pale limestone) may have been the most common materials which were used for roof coverings, but the roof was also often used to display prestige purposes and was therefore given a special design. The easiest way to achieve this was to use coloured, glazed tiles as was the case in the Lake Constance region (Überlingen) in the 15th century and evidence of which exists in Southern Tyrol (Trostburg) from the 17th century at least. The best known examples are the Gothic St Stephan's Cathedral in Vienna or the Hôtel Dieu in Beaune (Burgundy).

There are records of metal being used as an especially valuable covering as far back as the Early Middle Ages: for example, the Carolingian collegiate church at Hersfeld (Hesse) had a lead roof covering. There is no other example of the use of gilded roof tiles, however, and they were of key importance for the prestigious appearance of the Neuhof. There was no other colour or material which could beat gold as the most valuable of materials, even though the gold on the tiles is only a fraction of a millimetre thick.

standing. The composition of this stone zoo does not appear to follow any specific principle, some of the animals fighting or hunting one another while others are placid. The animal frieze is probably a decorative enhancement of the balcony, without any profound symbolic significance. Above this timberwork, the loggia is decorated with and closed off by ogee arches featuring tracery and crockets (foliage). The two corners of this section each include two small statues; the two to the left look to the sky, while the two to the right, which include a king, are looking down to the street. Above these eaves is the roof area, which is covered with gilded copper tiles and which gleams especially brightly when the sun is shining.

Tour of the interior

The interior of the Neuer Hof has undergone extensive conversions on a number of occasions such that, today, the character of the front building at least is largely that of an official building or an apartment building. Only the "Stöckl" in the courtyard has retained its vaulted Late Gothic rooms. The front building has five floors while the bay window projection itself has only three. The heights of the floors have changed as a result of the conversions. The bay-window floors used to be identical to the original floor heights. We need to assume that, in around 1420, it was a four-storey building with three high storeys and one low, later three high, partly vaulted floors and a low floor, and in a third phase a four-storey building with four floors of about the same height; it was a five-floored building as of 1822. The bay window was added between the first and second phases.

In a submission dating from around 1510 the court officials lamented the fact that there were hardly any vaulted rooms for the fireproof storage of the court files. The addition of the large number of vaults, at least on the ground and first floors can therefore be dated to the 16th century, either shortly after 1510 or after the earthquake in about 1572 at the latest. An extensive conver-

sion was undertaken following the earthquake of 1670. 18th century elevations show the building as four-floored, with a ridge-and-furrow roof, baroque windows and the earthquake reinforcements in its lower section. At this date, the changed storey heights still in existence today were already a problem, and as a result the vaults on the 1st floor at least had to be removed again.

The present-day interior is largely the result of the 1822 conversion as well as of simplifying conversions in the 20th century, the neo-classical staircase and front door being worthy of specific mention. The **ground floor** still retains its previous height and parts of the original vaulting, but the vaulting compartments were obviously flattened on the upper surface during the 1822 conversion at the latest, and some of the vaults on the upper floors were removed in favour of lower ceilings.

The bay window and loggia rooms. The **1st floor** is reached by way of the neo-classical staircase; the visitor enters the corridor extending to the street façade, at the end of which is the lower bay window room. It is closed to the street by a window front and has elaborate rhombic vaulting on the inside.

The upper balcony or loggia floor, the **2nd floor**, can be viewed by visitors only indirectly (via a mirror) in order to protect the highly endangered murals. The open loggia is very narrow. As a result of the conversions of the building, the loggia is today reached by climbing up a number of steps from the corridor on the 2nd floor. The loggia is covered by three-bay, very richly decorated net vaulting supported by eight wall and corner corbels which originally all supported figures. A jester and a drummer can be seen on the loggia wall facing the square, while there are two statues of women on the inner side and a nobleman on the side of the loggia: the other three pedestals are empty.

In addition to ornamental vines, the rib intersections feature around 70 little figures and coats of arms against a dark blue background. Here too,

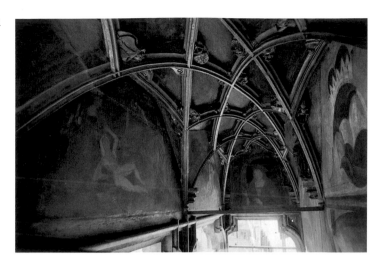

View of the loggia vaulting.

many of the coats of arms are related to Maximilian and/or the Habsburg's family connections. As might be expected, the majority of these coats of arms are located on the central axis. They are, in sequence, the coats of arms of Saxony (Katharina of Saxony was the wife of Archduke Sigmund), Portugal (Eleonore of Portugal was Maximilian's mother), the Holy Roman Empire, the Kingdom of Germany and the Sforzas' serpent coat of arms, the latter two each being linked in the manner of arms of alliance. The row ends with a crescent moon, such as often appears in midnight blue vaults. This has been the subject of much speculation regarding its possible symbolic relevance as an "imperial moon". The many other coats of arms, not all of which can be identified, also include Tyrol's eagle coat of arms and a shield with a fountain column, thought to be the emblem of the Türing family of stonemasons. This would mean that Nikolaus (Niclas) Türing left his signature on the building in this way.

Many of the coats of arms are held by very imaginatively designed supports featuring a variety of interpretations of the carrying motif. There are numerous little figures similar to those on the entrance vault distributed amongst the coats of arms and the foliate ornamentation. They include musicians, wildmen, naked figures, wrestlers,

dancers as well as a slumbering monk and a noble lady. A naked posterior appears between two of the coats of arms. There are also a number

The net vault in the lower bay window (balcony) room.

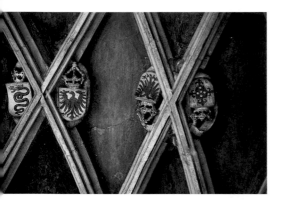

Coats of arms on the middle axis of the vaulting: Sforza, kingdom, empire, Portugal.

The moon on the middle axis of the vaulting.

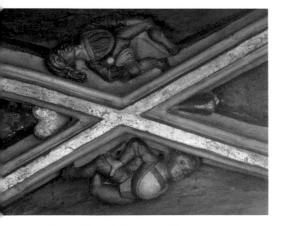

Two small figures in the loggia vaulting.

Statue at base of vaulting rib.

of features to be discovered between the narrow spandrels, such as masks, hands, a nose, a bell or a golden heart.

The vaulting depicts the entire repertoire of comic and grotesque late medieval figures between the coats of arms. It therefore fits in with the rest of the balcony, where genealogy and claims to power are also associated with the antics of Moorish dancers, jesters, naked creatures and wildmen. This curious mixture of gravity and gaiety, power displays and folly also characterizes the large fresco on the rear wall of the loggia.

The **wall painting** taking up the whole of the rear wall depicts a court gathering in front of a building façade, embedded in illusionist architecture. The figures are arranged in small groups but there does not appear to be a common activity or context. On the far left are two well-dressed ladies somewhat elevated in a long, far-reaching passageway. They appear to be deep in conversation. Standing opposite one another on the threshold to the building are a lady in a red dress

with costly ermine trimming and an elaborate bonnet and a man dressed as a jester. The jester is touching the lady in her lap with an obscene gesture, while she has laid her left hand on his chest. Her right hand is extended towards the little horse, grasping its muzzle. The horse is standing on a low pedestal and is led by a man who looks like a peasant with a wide-brimmed hat, who appears to be standing behind the horse. The bearded old man in front of the horse has removed his headdress and is holding a staff in his left hand. Next to him stands an elegant youth in a red, fur-trimmed coat and a plumed hat, carrying a rolled-up document in his hand. Between them is the diamond-patterned collar of a figure with its back turned.

The Late Gothic loggia portal is incorporated into the illusionist architecture; the perspective of the painted vaulting is viewed from two consoles above the door, thus balancing out the lack of symmetry between the door and the vault. On the other side of the loggia entrance is a young, elegantly dressed couple in conversation. He is wearing a short, yellow and blue diamond-patterned cloak and a tall, pointed plumed hat, while the lady is wearing a red dress with puff sleeves. Above the two of them is another lady with loose hair looking out of a window. On the very edge are the outlines of the figure of a jester looking over the balustrade towards the Imperial Palace. His counterpart on the left hand side is a small, long-tailed monkey playing with a ball.

The significance of this wall painting has been the subject of much speculation. Some of the figures exhibit a vague similarity to relatives of Maximilian and the entire scene has therefore been interpreted as a kind of encoded Habsburg family gathering. While the elegant youth in the red coat next to the loggia door does indeed exhibit some similarity to some of the portraits of Maximilian's son Philip the Handsome (1478–1506), there are enough other depictions of Philip which

View of the façade painting on the loggia floor in its present day condition. Coloured drawing M. Schmidt (HBR).

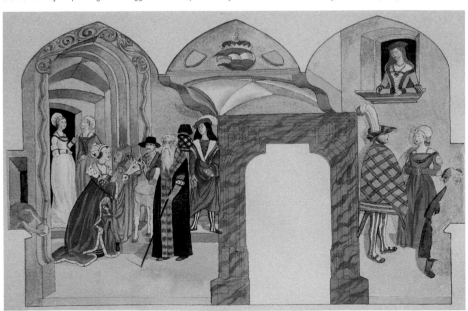

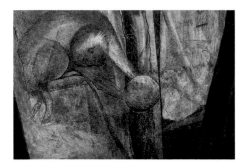

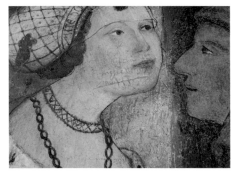

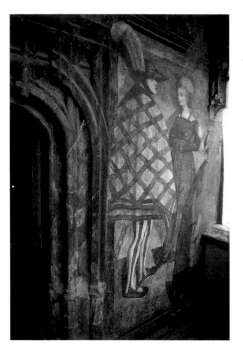

The wall painting in the loggia left of the portal.
Above: the little monkey with the ball
Below: Graffiti on the lady's face "Fiegger von Melans".

The wall painting in the loggia right of the portal.
A man with a diamond-patterned cloak meets a lady.

contradict this identification. What is noteworthy is that none of the figures is distinguished by a specific feature, coat of arms or attribute. In the case of Philip the Handsome, for example, the chain of the Order of the Golden Fleece, which he received as a young boy, is missing, and in the image of the lady at the window which is supposed to be his spouse, Juana of Castile, the loose hair contradicts such a comparison. Loose hair was generally a sign of virginity and/or of a bride and Juana and Philip had been married since 1496.

The identification of the jester and the lady in the ermine gown is especially problematic. They are often interpreted as Maximilian I and Bianca Maria Sforza, but there is no evidence to support this. The assumption is based on reports that Maximilian was especially fond of any kind of "masquerade" (fancy dress parties) and had even

donned the jester's costume himself on at least one occasion. The jester does not exhibit any of Maximilian's special features, however, such as his prominent nose, which is visible in the reliefs below. Even though the Golden Roof is teeming with jesters and grotesque figures, the German king and his closest family members are never equated with these. The respective location plays an important role in the interpretation of artworks and it is hard to imagine that the future emperor would have let himself be captured for posterity as a jester in an obscene context on such a prestigious building.

Endeavours to identify the figures with members of the Habsburg court are also thwarted by the fact that the majority of the heads have been extensively renovated, many of the original details having been painted over in the 18th or 19th centuries. The renovated figures are easily

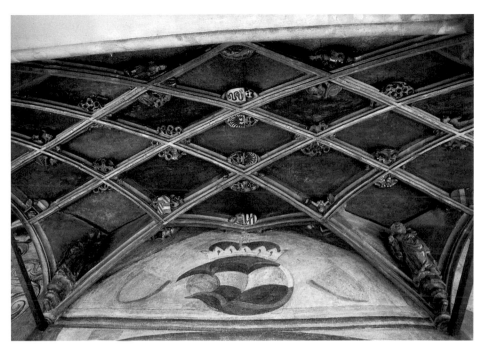

The net vaulting in the middle span of the loggia with the ducal coat of arms.

identified by the fact that they do not exhibit any of the graffiti with which the original sections of the painting are littered. This graffiti, which begin shortly after 1500 and which primarily date from the 16th and early 17th centuries, largely comprise the initials of visitors. But some of them also comment on the painting, for example the obscene gesture of the jester, however and are therefore of immense historical and cultural value.

The early graffiti in fact confirm that the wall painting was created at the same time as the completion of the balcony in 1500. A number of later overpaintings can be identified from a distance, for example the arch of the painted building entrance, which is framed with baroque tendril ornamentation, possibly the result of renovation work following the 1670 earthquake. Above the vaulted doorway at the entrance to the loggia

is the ducal coat of arms of Tyrol, crowned by the ducal hat, which suggests an addition after 1521. Following Maximilian's death and a brief joint regency of his grandsons, Karl V ascended the royal throne, while Ferdinand was awarded the title of Archduke of Austria in 1521, before becoming king in 1531 and succeeding his brother as emperor in 1558.

The paintings beneath the vaults of the open loggia may be additions at a somewhat later stage. The lunette images exhibit a different technique to that of the painting on the rear wall, which is a fresco, while the lunettes are *al secco*, that is, painted on dry plaster. This technique is one of the reasons for their poor state of preservation. With a little effort, the images can be identified. the left hand painting on the square side is of Samson's fight with the lion, in the middle is the scene with Samson and Delilah, who cuts his hair

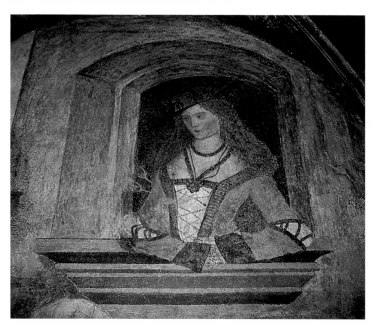

*The wall painting in the
loggia right of the portal.
A woman looking out of
the window.*

*"The Sea Monster", copper engraving by Albrecht Dürer,
circa 1498.*

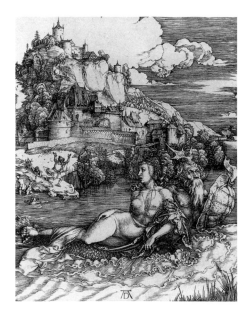

*The wall painting above the loggia opening. The kidnapping
of a young woman by a sea monster, based on Albrecht
Dürer's copper engraving "The Sea Monster".*

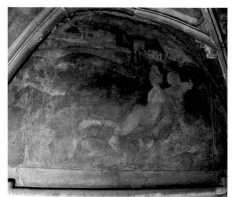

and thus robs him of his legendary strength, and on the far right is the "Sea Monster", based on an engraving by Albrecht Dürer. The artist probably also used a Dürer engraving as the basis for the lunette image on the left.

The half-length portraits of a man and woman in a painted archway are visible on the narrow sides to the left and right. The well-dressed woman is holding a blossoming twig and the man a red ball, possibly an apple. Both of their gestures indicate that they are speaking to one another across the room. They, too, have been identified as Maximilian and Bianca Maria but the apple and the twig are insufficient as attributes to confirm such an interpretation of these very faded paintings.

The courtyard and the rear building (the "Stöckl")

The approximately square three-floor courtyard building dates from 1459 or shortly thereafter. The interior with the vaults supported by a central column may date from after 1510 but this has not been confirmed definitively. The windows with the small tracery friezes date from around 1459, however. Originally the building had no windows facing the neighbouring property to the West and this additional property was only acquired after 1620. It is also easy to see the extent to which earthquake pillars were later added to the courtyard building, and the same applies to the courtyard side of the front building. It is also apparent that the passage between the front and rear buildings dates from the 20th century in its present form. A simple wooden bridge was probably all that was in place originally. The 2nd floor of the courtyard building serves as a museum today. It is a room featuring elaborate architecture, its stucco ribbed vaulting being supported by a round central pillar and twelve polygonal pilasters. The architecture is Late Gothic: there are pointed-arch entrances extending from the front room (front building) and from a side room which has been substantially modernised, however. There must have been an open passage-

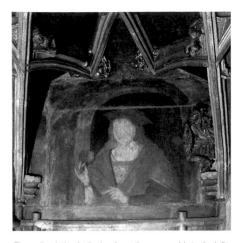

The wall painting in the loggia on the narrow side to the left. A man with an apple.

The wall painting in the loggia on the narrow side to the right. A woman with a twig.

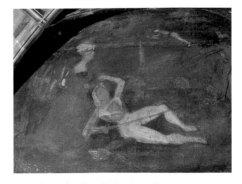

The wall painting above the loggia opening. Samson is overpowered by Delilah.

way leading to the front door initially because the adjacent window with the tracery frame formed part of the earlier court area.

Summary

It was probably between around 1497/98 and 1500 that the Golden Roof was built on to the Neuhof, itself probably in existence since 1420. The Neuhof was extended by the addition of the courtyard building in approximately 1459. At that time the Neuhof had three high floors and a low upper floor beneath a ridge-and-furrow roof. The Golden Roof was probably designed by Nikolaus Türing according to the specifications of Maximilian I and his artistic advisers. The simple stone-masonry work such as vaulting ribs, ornamental architectural sculptures and probably the more demanding figures, for example the frieze of coats of arms and the dance reliefs, were probably also carried out by the Türing workshop. The wall paintings on the balcony floor were also created in around 1500 but were later reworked several times, as were the huge standard bearers

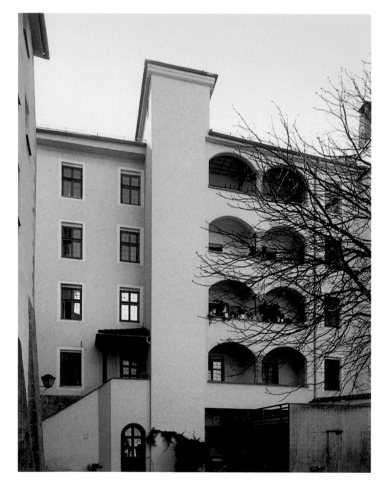

Courtyard view of the front building.

The 1459 courtyard building, full view.

Pages 38/39: The interior of the "Stöckl" with the central column and the ribbed vaulting on the 2nd-floor (museum).

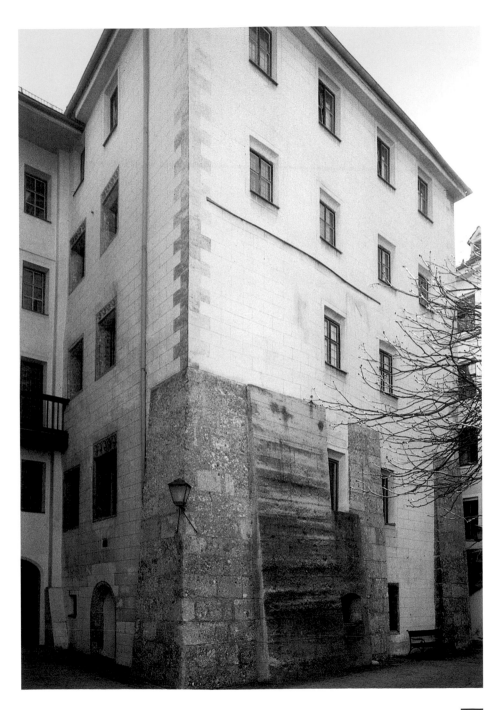

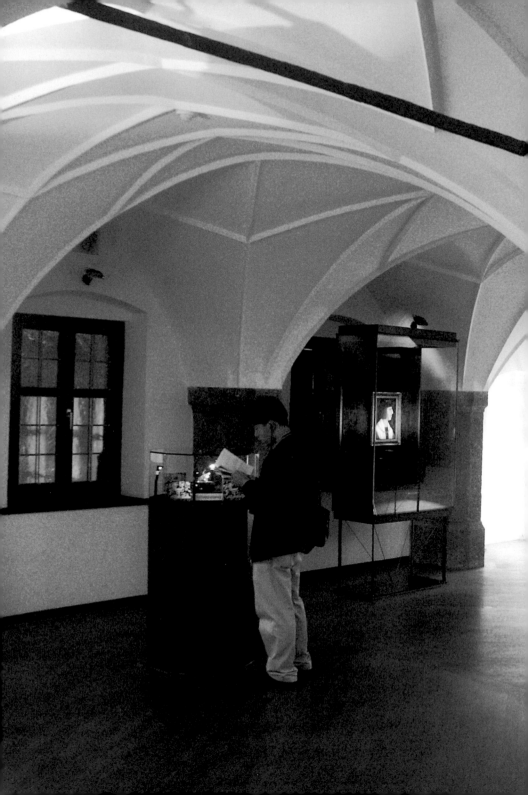

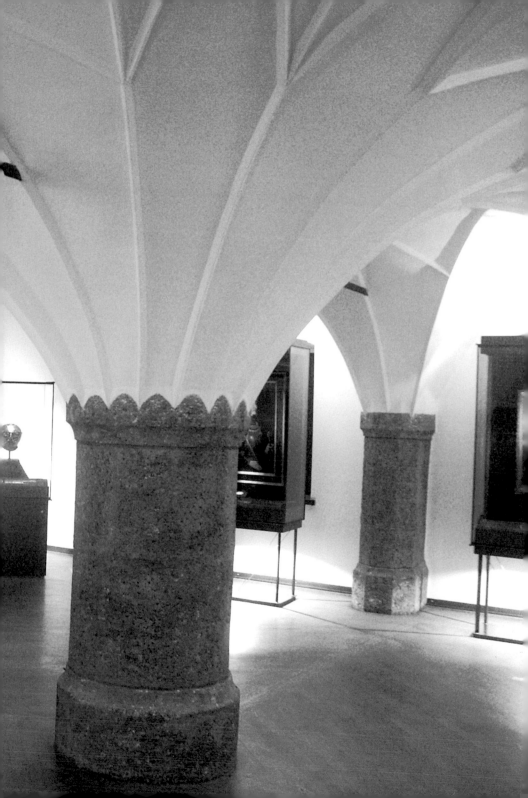

at the front. The artist known as Master FS has been identified here for the first time as the creator of the frescoes, his signed and dated wall painting in the neighbouring Stiftskeller building exhibiting the greatest similarities with the Golden Roof's balcony paintings.

There remains the question of the Golden Roof's significance and function. A bay window construction with a loggia gallery was nothing special in about 1500, but its size, and more especially the golden tiles, make the Golden Roof unique. Structures of this kind were mainly used

Late Gothic tracery window in the courtyard building from 1459.

Gregor Türing's heraldic seal on a document dating from 1540 in the Innsbruck City Archive.

Door and window on the second floor of the "Stöckl", 1459.

The artists

The Golden Roof constitutes a complete work of art, comprising architecture, sculpture and painting and one in which several artists were involved. The only historical source referring to the building does not name any masters, however. This means that stylistic comparisons need to be made in an attempt to ascribe the sculpture and paintings to known masters, a process which art historians refer to as "ascription". While researchers are in relative agreement on the creator of the stonemasonry are in relative agreement, opinions regarding the ascription of the paintings differ considerably.

The stonemason. The Golden Roof stonemasonry is generally considered to be the work of **Nikolaus (Niclas) Türing.** Thought to have come from Swabia, he was the master sculptor at Maximilian's court. His son Gregor, considered by some to be the creator of the frontal reliefs on the balcony, ran the workshop following his father's death in 1517. There are hardly any works which can be ascribed to Niclas Türing with absolute certainty, however. Proof of his creatorship is considered to be his little family crest on the loggia vaulting, which is to be seen as a signature. Niclas Türing was active not only as a stonemason but also as a master builder, with master builders in around 1500 playing the combined role of today's architect, foreman and overseer. It is therefore most likely that the overall plans for the Golden Roof can be ascribed to Türing – in consultation with Maximilian and his advisors.

The painter. Far more difficult to resolve than the issue of the stonemason is that of the creator of the paintings, particularly as large sections of the frescoes have been renewed and/or badly damaged. Mention of the name Jörg Kölderer is made most frequently in connection with the Golden Roof. The artist, who came from Inzing in Tyrol, worked as a painter and draughtsman for Maximilian as of 1497, being appointed court painter shortly thereafter. His responsibilities, however, mainly encompassed routine work as a painter-decorator, assisted by the court workshop, as well as the painting of coats of arms and banners. He drew plans and maps and later ran the court building department, to use modern terminology. There are no historical sources relating to the Golden Roof which confirm him as creator, and a stylistic ascription is not possible either because none of Kölderer's works of a comparable scope and quality have survived.

The greatest degree of conformity with the Golden Roof paintings is to be found in a wall painting dated 1505, which is located in the Stiftskeller, the former armoury, less than 300m from the Golden Roof. The large fresco depicts a man with a diamond-patterned cloak in the centre who is climbing a spiral staircase; other figures can be recognised in the remains of the fresco. This architectural painting with its largely coherent perspective is signed on one of the steps with the alloyed letters FS. The previously unknown **Master FS** is most likely to have been the Golden Roof painter. He was probably not a journeyman of Kölderer's, but rather an external artist used for such special commissions.

for show, similar to a monumental signboard. In addition to being seen, however, seeing itself also played a role and balconies were therefore favoured viewing platforms for house owners on the occasion of celebrations or processions, for example. At first glance the Golden Roof meets all of these requirements: it occupies the most prominent position on the city's main square and is visible far beyond each of the city gates, its radiance being very effectively emphasised by the golden tiles. As the city's focal point Maximilian, carved in stone as king and emperor, looks down on his subjects and visitors, while two giant standard bearers stand at his side, fierce and faithful. It should not be forgotten, however, that the building on which the Golden Roof was built was not a residential building but purely a rather sober administrative building. The actual residence which also housed Maximilian's wife Bianca Maria and the royal household occupied a much less prominent position on a side street. Maximilian himself was seldom present in Innsbruck and when he spent time in Tyrol it was usually in one of his many castles serving as hunting lodges. Therefore the Golden Roof is indeed to be seen as a gleaming symbol of power but one which was also permanently present even when the king and/or emperor was absent. This serious purpose seems to be contradicted by the roguish pictorial programme. It is astounding that Maximilian, whose rule was in no way secure at the time the bay window was built in around 1497–1500, allowed himself to be depicted in the company of jesters, grotesque dancers and obscene figures. A similar pictorial programme on a present day administrative building would be unthinkable. A court feast of the kind depicted by the wild Moorish dancers is unlikely to have ever taken place in the Neuhof, such festivities having been staged in the nearby residence.

The scene on the rear wall of the loggia is based on an elaborate composition and does not depict a real situation, even though the illusionist painting gives this impression at first glance. The theory that it is a portrayal of the imperial family has

no basis. To judge from the clothing, the figures are members of court society engaged in conversations, masquerades or lovers' trysts, but there is no overall narrative context connecting the individual figures and groups. They are completely absorbed in their activities and are uninterested in what is taking place on the square in front of them, with the exception of the very faded jester on the right hand side who is pointing towards the Imperial Palace. The spectator aspect which one might expect on such a balcony features in neither the paintings nor the sculptures. Nevertheless, there is nothing to contradict the hypothesis that the balcony served as a spectators' gallery for the street festivals or processions which very probably took place on the square. When the king was present on such occasions it is possible that he preferred to show himself here rather than at a window in his residence. Special spectator tribunes were often erected temporarily for such festivities. These were decorated to suit the occasion and afforded more space for the royal household than the narrow showcase balcony. The fact that the Golden Roof was much frequented, however, is indicated by the many graffiti left by visitors on the fresco from the outset. These also include a number of prominent names such as Hans Fieger von Melans in 1524, a member of one of the region's most important families. The graffiti are a kind of monumental visitor's book which documents the history of the building more than any other source.

Maximilian's Golden Roof is in many ways much more than a normal bay window construction. Its size, the unusual pictorial programme and the golden tiles make the Golden Roof a prominent showpiece which retains its impact on visitors to this day. The sculptures and imagery are drawn from the entire repertoire of profane contemporary imagery which is presented to the observer here in an artistic manner and composition. There is a wealth of sights for visitors to discover on the

The Golden Roof.

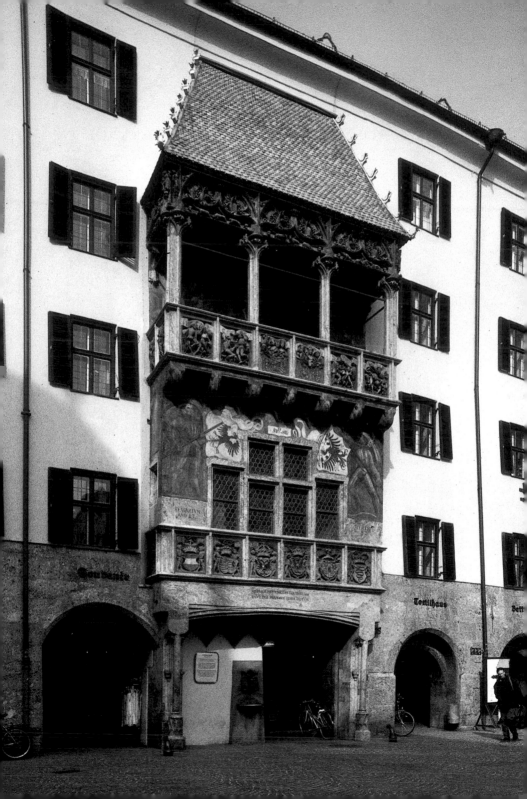

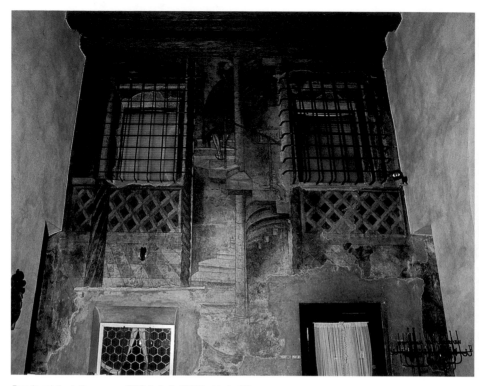

Façade painting in the armoury ("Stiftskeller"), 1505 by Master FS.

square, but this pales in comparison to the attractions on the loggia. The many vault figures and small coats of arms, as well as the lunette images, can only be seen from here. There are plenty of indications that even in Maximilian's time the loggia served as a balcony for display, which was shown to selected guests as if a picture gallery, the visitors leaving their mark for posterity with scribbles in the "visitor's book". In this respect the Golden Roof is a true innovation in both architectural and artistic terms.

Page 45:
Side view towards
Pfarrgasse.

Page 47:
The Golden Roof. Historical
photograph circa 1870/80.
The vertical building joint
between the Neuer Hof and
the adjacent building to the
left can be seen on the 1st
to 3rd floors to the left of
the balcony.

Bibliography

Johann Deininger: Die Restaurierung des goldenen Dachls in Innsbruck. In: Mittheilungen der K.K. Central-Commission für Erforschung und Erhaltung der Kunst- und historischen Denkmale. Vol. XXVI, New ed., Vienna 1900, pp. 124–129

Josef Schorn: Die Erdbeben in Tirol und Vorarlberg. In: Zeitschrift des Ferdinandeums für Tirol und Vorarlberg Vol. 46, Innsbruck 1902, pp. 97–282, esp. pp. 137–152

Josef Garber: Das Goldene Dachl in Innsbruck (Die Kunst in Tirol, Special Edition 4). Augsburg/Vienna 1922

Heinrich Hammer: Die Paläste und Bürgerbauten Innsbrucks (Die Kunst in Tirol, Special Edition 2). Vienna 1923, esp. pp. 31–37

Konrad Fischnaler: Das Goldene Dachl in Innsbruck. In: Der Burgwart, Zeitschrift für Wehrbau, Wohnbau und Städtebau, Vol. 26 1925, pp.1–8

Otto R. v. Lutterotti: Zur Meisterfrage beim Innsbrucker Goldenen Dachl. In: Beiträge zur Kunstgeschichte Tirols. Publication commemorating Josef Weingartner's 70th birthday (Schlern issue 139). Innsbruck 1955, pp. 95–102

Erich Egg, Wolfgang Pfaundler: Kaiser Maximilian I. und Tirol. Innsbruck 1969

Franz-Heinz Hye: Die heraldischen Denkmale Maximilians I. in Tirol. In: Der Schlern 1969, pp. 56–77

Ausstellung Maximilian I. Innsbruck. Innsbruck, undated (Ed. E. Egg)

Vinzenz Oberhammer: Das Goldene Dachl in Innsbruck. Innsbruck 1970

Österreichische Kunsttopographie Vol. XXXVIII. Innsbruck, Part 1. Die profanen Kunstdenkmäler der Stadt Innsbruck. Die Häuser. Vienna 1972, pp.102–131 (Text: Johanna Felmayer)

Rainer Prandtstetten, Manfred Koller: Goldenes Dachl in Innsbruck – zur Restaurierung 1975. In: Restauratorenblätter 3, Vienna 1979, pp. 321–340

Johanna Felmayer: Das Goldene Dachl in Innsbruck. Maximilians Traum vom Goldenen Zeitalter. Innsbruck 1996

Franz-Heinz Hye: Das Goldene Dachl Kaiser Maximilians I. und die Anfänge der Innsbrucker Residenz (published by the Innsbruck City Archive, New ed. 24). Innsbruck 1997

Paul Vandenbroek: De kleuren van de geest. Dans en Trance in afro-europese tradities

Ausst.-Kat. Koninklijk Museum van Schone Kunsten. Antwerp 1997

Erwin Pokorny: Minne und Torheit unter dem Goldenen Dachl. In: Jahrbuch des Kunsthistorischen Museums Wien. Vol. 4/5, 2002/2003, Mainz 2004, pp. 30–44

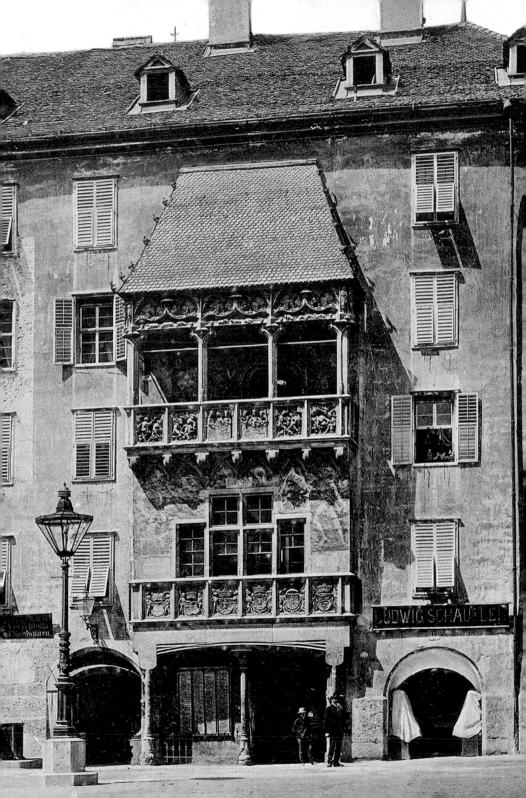

1st English edition 2009
© Verlag Schnell & Steiner GmbH,
Leibnizstraße 13, D-93055 Regensburg
Production: Erhardi Druck GmbH, Regensburg
ISBN 978-3-7954-2188-5

Translation: Katherine Taylor

Front cover:
The Golden Roof in Innsbruck.

Back cover:
The Golden Roof, steel engraving from the mid-19th
century, drawn by Martens.

This page:
View of the Golden Roof, steel engraving circa 1830,
detail.

Illustrations:

HBR Nuremberg: pp. 7 below, 12, 14, 15, 31.
Stadtarchiv Innsbruck: pp. 6 below, 8, 9
above, 47, 48 and back cover flap.
Museum Ferdinandeum, Innsbruck: p. 23
below.
Germanisches Nationalmuseum, Nuremberg:
pp. 1, 5, 7 above, 34 below left.
All other illustrations: G. Ulrich Großmann.

Acknowledgements

A particular debt of gratitude is owed to the
former director of the Tyrolean Provincial
Museum (Ferdinandeum) in Innsbruck, Gerd
Ammann, for his support with the research
work, to the staff of the Innsbruck City Archive
and to the Golden Roof administration. A
special vote of thanks also goes to Dr. Jutta
Zander-Seidel (Germanisches Nationalmuseum,
Nuremberg) for the help given to the authors
with regard to the clothing in the frescoes.

Burgen, Schlösser und Wehrbauten in Mitteleuropa vol. 18

Published by the

 Wartburg-Gesellschaft

Bibliographic information The German National Library

This publication is recorded by the German National
Library in the German National Bibliography; detailed bibli-
ographic data are available in the internet at
<http://dnb.ddb.de>.

ISBN 978-3-7954-2188-5

Already published

Vol. 1: Nürnberg, Kaiserpfalz
Vol. 2: Büdingen, Schloss
Vol. 3: Marburg, Schloss
Vol. 4: Eisenach, Wartburg
(German, English and French)
Vol. 5: Schleswig, Schloss Gottorf
Vol. 6: Ronneburg in Hessen
Vol. 7: Die Drei Gleichen
Vol. 8: Burg Ranis
Vol. 9: Neues Schloss in Ingolstadt
Vol. 10: Festung Wülzburg
Vol. 11: Burg Fleckenstein im Elsass
(German and French)
Vol. 12: Moritzburg in Halle an der Saale
Vol. 13: Schloss Detmold
Vol. 14: Schloss und Zitadelle Jülich
Vol. 15: Schloss Horst (Gelsenkirchen)
Vol. 17: Schloss Rheinfels
Vol. 18: Innsbruck, Goldenes Dachl
Vol. 19: Forchheim, Burg und Festung
Vol. 20: Burg Runkelstein
(German and Italian)
Vol. 21: Bozen, Schloss Maretsch
(German and Italian)
Vol. 22: Trient, Schloss Buonconsiglio